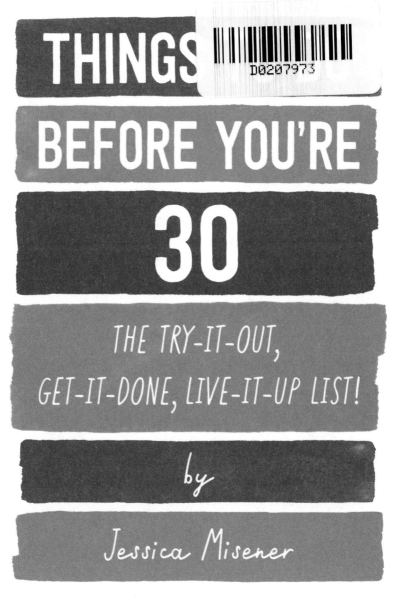

THINGS

BEFORE YOU'RE

30

THE TRY-IT-OUT, GET-IT-DONE, LIVE-IT-UP LIST!

by

Jessica Misener

ADAMS MEDIA

NEW YORK LONDON TORONTO SYDNEY NEW DELHI

For my parents.

Adams Media
An Imprint of Simon & Schuster, Inc.
57 Littlefield Street
Avon, Massachusetts 02322

First Adams Media trade paperback edition APRIL 2018

ADAMS MEDIA and colophon are trademarks of Simon and Schuster.

For information about special discounts for bulk purchases, please contact Simon & Schuster Special Sales at 1-866-506-1949 or business@simonandschuster.com.

The Simon & Schuster Speakers Bureau can bring authors to your live event. For more information or to book an event contact the Simon & Schuster Speakers Bureau at 1-866-248-3049 or visit our website at www.simonspeakers.com.

Interior design by Colleen Cunningham
Interior images © Getty Images/saemilee; 123RF/Tatiana Alexandrova

Manufactured in the United States of America

10 9 8 7 6 5 4 3 2 1

Library of Congress Cataloging-in-Publication Data
Misener, Jessica, author.
Things to do before you're 30 / Jessica Misener.
Avon, Massachusetts: Adams Media, 2018.
LCCN 2017057171 (print) | LCCN 2017059532 (ebook) | ISBN 9781507207338 (pb) | ISBN 9781507207482 (ebook) '
LCSH: Young adults--Conduct of life. | Young adults--Life skills guides.
LCC BJ1661 (ebook) | LCC BJ1661 .M57 2018 (print) | DDC 646.70084/2--dc23
LC record available at https://lccn.loc.gov/2017057171

ISBN 978-1-5072-0733-8
ISBN 978-1-5072-0748-2 (ebook)

HOW TO USE THIS BOOK

I had my thirtieth birthday party at a trendy bar in Brooklyn. I wore a red dress and a smile. But just an hour before, I'd been a nervous wreck. Turning thirty was a huge milestone, and unlike turning twenty-one, this birthday didn't come with an exciting rite of passage. It just felt scary. At dinner before the party, my anxiety swelled to a level that even the mac and cheese I was eating couldn't cure. I excused myself to the restroom and stared at myself in the mirror, bargaining. Maybe I could skip my own party, or just stay twenty-nine forever? Luckily, my friends made sure I got in the cab with them, and I ended up having an absolute blast.

Powering through my fears and throwing that party sums up the biggest lesson I wish I had learned before turning thirty: how to accept who I am, "flaws" and all.

In *Things to Do Before You're 30* I've compiled more than 600 bucket-list items everyone should complete before celebrating their big three-oh. From

smaller feats you can achieve in your day-to-day life to important life skills and must-see places around the world, *Things to Do Before You're 30* has everything you need to make the most of your twenties. Pick a small item or two to complete during the week, or plan an entire trip with a bucket-list activity in mind.

Now is the time to figure out being an adult, but it is also the time to live it the heck up. Push back against the boundaries of your own routine. Conquer a phobia, watch burly German men dance the polka at Oktoberfest, let go of old grudges between siblings. These are the years of *you*.

Something else to remember: your bucket list doesn't magically end after twenty-nine. You can bring your unfinished list items into your thirties, or even redo your favorite ones over and over. Turning thirty can feel like the period at the end of a really long sentence, but the truth is that it's just a comma.

HASHTAG CHALLENGE: want to connect with the *Things to Do Before You're 30* community? Just post pictures of yourself tackling your list items to *Instagram* with the hashtag #ThingsBefore30, and check out pictures posted by others of their own bucket-list achievements.

- **Run barefoot through the cool summer grass waving sparklers.**

- **Go to Coachella or another music festival.**

After you turn thirty, your enthusiasm for music festivals will go way down. Grab a bunch of your closest friends and embrace the chance to wear your craziest costumes, camp out or stay in a cabin, and put your responsibilities on hold for a week.

that sound was a million thirty-somethings mumbling in agreement

5

■ **RELEASE A PAPER LANTERN INTO THE NIGHT SKY AT A LANTERN FESTIVAL.**

■ **Bring a gift, such as cookies or a candle, to your new neighbors.**

Bringing a small gift to new neighbors can help them feel more at home—and **those friendly relationships make all the difference** when you are in need of a cup of sugar or someone to keep an eye on your plants when you are out of town.

■ **Share a special song with someone.**

■ Read *Americanah* by Chimamanda Ngozi Adichie.

This spectacular, award-winning novel chronicles a young Nigerian immigrant woman's journey in America. The main character's struggles with homesickness and identity will resonate deeply with the challenges you face during these uncertain years in adulthood.

■ Dance until you drop at a friend's wedding.

■ **Have your portrait taken.**

Whether you get a professional photographer to style and snap you or just have a friend take some artsy candids for social media, you'll capture a slice of your life that you'll have forever.

plus, it's a good excuse to splurge on a really nice outfit

■ Go to a taping of a popular game show.

Go vegan for a month.

It's not so bad: **Oreos are vegan!** A vegan diet, even in the short term, is a great way to detox your body, appreciate what goes into the food you eat, and possibly feel better than you ever have. Maybe you'll even become vegan for life.

Swim in an infinity pool.

Rewatch your favorite childhood movies.

They stand the test of time, and you may notice new, hilarious things as an adult that you totally missed as a kid.

whoa, adult Simba and Nala were really, uh, getting to know each other well in that field...

- **READ ALOUD TO YOUR PARTNER IN BED, AND VICE VERSA.**

- **Take your parents out to dinner—and pay.**

Even if you can only afford burrito bowls at the nearest taqueria, they'll appreciate the gesture.

- *Visit a rose garden.*

Literally stop to smell the roses.

■ Buy cute or funny greeting cards and mail them to your friends randomly.

I moved from New York to California by myself when I was thirty, and it not only scared the crap out of me in general, but made me intensely anxious about losing touch with people I used to talk to every day. One way I coped with being so far from my friends and family was **developing a new love of snail mail**. I'd pick up cards whenever I was in one of those trendy home decor stores—you know what I mean—and mail them out on a whim. Who doesn't love checking their mailbox and finding something other than yet another credit card offer and an electric bill? A book of stamps costs mere dollars, but making your friends' day when they see a personal envelope awaiting them is priceless. Plus, it's helped me maintain those relationships I was worried would fade with distance.

■ Spend the night in a castle.

■ Make s'mores over a bonfire on the beach.

Or, try toasting Starburst candies—yes, this is a thing! They get really crunchy on the outside and gooey like a marshmallow on the inside.

■ **Ask your grandparents what they were doing when they were your age.**

Were they already married with three kids? Working at a factory or in medical school? Serving in the army?

■ **FIND YOUR SIGNATURE SCENT.**

■ **Listen to Martin Luther King Jr.'s "I Have a Dream" speech.**

You can find King's moving speech online for free and learn firsthand how one man rallied a nation. Soak up King's beautiful rhetoric and meditate on the freedom he let "ring" across America. You might even feel inspired to make a difference (big or small) in your own community.

- **LEARN HOW TO SKI OR SNOWBOARD.**

- **Look up restaurant menus in foreign cities and decide what you would order.**

 Even better: go to one of those restaurants.

- Learn how to rock climb.

Play hide and seek in an IKEA.

Even as you get older, it's important to tap into your inner child, and shopping for mundane necessities like couches and laundry hampers is definitely a good time to channel some playful vibes.

pro tip: hide near the cinnamon rolls

Set up a monthly recurring donation to a charity, even if it's just $5.

Cut back on your car usage.

Not only is owning a car expensive—all that gas and maintenance—but auto emissions contribute in no small way to our planet's climate change crisis. Even if you live in an area where public transportation is sparse and biking isn't possible, **try carpooling with a coworker** when you can so you both save on gas and mileage costs, and help the planet too!

- Set up two like-minded friends on a date.

- Go fly a kite.

 No, actually get a kite and fly it.

- **See the towering *Christ the Redeemer* statue in Rio de Janeiro.**

- Go to a family reunion.

■ Start a blog.

It can be about puppies, recipes, your travels—or anything, really!

■ Work a menial job.

Bussing dirty milkshake glasses off tables or folding jeans at a clothing retailer isn't exactly thrilling, but dealing with cranky customers is a humbling experience, and **it taught me life skills I wouldn't have learned otherwise**. One time when I was working as a grocery store cashier, a woman threw a pie at me! Experiencing the invisibility of working a service job teaches you empathy and to not take things—like pie-throwing—personally. You'll see the best and worst of humanity when you work with customers, and you'll never treat servers or cashiers poorly once you've been in their shoes.

I don't even think it was a good flavor

- **Create a new drinking game with your friends.**

- *Learn how to belly dance.*

- Visit the Eiffel Tower.

 Climb to the top to overlook Paris, or view the famous monument from a boat on the Seine.

■ TRY EVERY FLAVOR OF CHEESECAKE AT THE CHEESECAKE FACTORY.

I recommend starting with white chocolate raspberry truffle.

■ Watch the northern lights.

■ Say no to an invitation for something without giving an excuse.

I wasted so much energy in my twenties saying yes to every invite, even ones I didn't want to accept, or making up lies about having plans I couldn't cancel. Don't be like me! You don't owe anyone your time, and it's okay to take a night off from your social life.

like an improv show that started at ten p.m. on a Tuesday night

■ Start your own email newsletter.

Services such as *TinyLetter* and *MailChimp* make it easy for people to sign up for **regular digital missives** of your thoughts, artwork, comedy, or professional updates.

■ Fly in a hot air balloon.

■ LEARN HOW TO DRIVE A STICK SHIFT.

■ Feel the cool spray from Niagara Falls on your face.

From a safe distance. Not a barrel.

the stuff you buy cheap at many clothing chains

■ **Research the origins and sustainability of the clothes you buy.**

Fast fashion isn't always the friendliest when it comes to factory conditions and humane treatment of workers. One easy way to wean yourself off the fast fashion habit, if you want, is to buy more clothes secondhand from thrift and resale stores. There are also clothing companies that dedicate themselves to sustainable practices.

■ GET IN A WATER BALLOON FIGHT.

- # Research your family tree.

- # Send a social media message to someone you haven't talked to in a while.

 I know, I know. But you don't have to message your awkward junior year prom date or that girl who constantly tries to get you to buy things from her online store. Pick someone you have simply lost touch with but whose company you enjoy, and give her a shout.

 it takes thirty seconds and you might restore a vibrant friendship

- # HAVE ICE CREAM FOR DINNER.

 You're not dredging through adulthood now for nothing. Give yourself a treat!

- Stay home on Halloween and pass out candy to trick-or-treaters instead of going out.

- **Down a stein (or three) and watch the polka dancers at Oktoberfest in Germany.**

Held annually in Munich, Oktoberfest features over thirty different tents, each waiting to offer you specialty beers once the mayor of Munich taps the official first keg at high noon on day one.

- *Catch fireflies on a warm summer night.*

■ Read *The Marriage Plot* by Jeffrey Eugenides.

This is one of those books I read in my twenties that captured everything I was feeling and thinking at that period of life with exquisite emotion. Madeleine's endeavors following college graduation will remind you that it's okay to not have adult life figured out.

■ *Get a projector and host an outdoor movie night.*

■ LEARN HOW TO PLAY CHESS.

Unless you're some type of Harry Potter–esque genius, it's really hard to be amazing at chess, but it's not hard to learn the basics.

■ **Recreate your favorite childhood photos.**

■ *Use the* FORD *acronym.*

Stuck not knowing anyone at a party or wedding? Here's an easy guide to making (*gulp*) small talk with strangers:

F: Family—Ask them about their parents, siblings, or close friends.

O: Occupation—Ask them what they do for a living. What's their commute like? How long have they worked there?

R: Recreation—Ask about their hobbies, travel plans, exercise routine, or favorite toy from childhood.

D: Dreams—Ask them what they *wish* they did for a living, or where they would most want to go on vacation.

■ **FINALLY LET A FRIEND LIVE DOWN AN EMBARRASSING MOMENT.**

■ Learn how to DJ.

DJing is more than just pressing play on a playlist; you'll get up to speed on **how to mix, scratch, and spin** your own music.

■ Write your name somewhere in your favorite city.

■ Work for a boss you truly admire.

Whether it's a store manager or a creative director, find someone who inspires you to pursue greatness and makes you excited to show up every day.

- **RALLY ALL OF YOUR FRIENDS FOR A GAME OF PAINTBALL.**

it's really not that bad!

- **Do your own taxes.**

 Accountants are expensive, and your parents can't tackle your W-2s forever. With products like TurboTax and TaxSlayer, you can easily get everything organized, entered, and filed off in just a few hours.

- *Eat divinely sweet baklava in Turkey.*

▪ Read the works of Joan Didion.

Didion captures the beautiful uncertainty of being in your twenties in simple, yet aching prose. Her writings, particularly her 1968 collection of essays titled *Slouching Towards Bethlehem*, put into real words all those ineffable things you feel when standing on a busy street corner or gazing out at the Pacific Ocean.

▪ Watch bodybuilders grunt their way through pull-ups at Muscle Beach.

▪ Solve a Rubik's Cube.

If you're like me, this small colored cube drove you nuts as a kid. Finally conquer the childhood classic, even if it takes you weeks.

- Taste all the crazy flavors of soda at the World of Coca-Cola museum in Atlanta.

- ## MASTER THE ART OF SURVIVING A BREAKUP.

 Like many people, you'll probably experience a number of breakups in your twenties, from the completely soul-destroying to the more manageable but still painful. Breakups often feel like a small death, and the pain afterward like a type of mourning— mourning not only the past relationship, but the future you'd planned and imagined with that person. At the time, the wound of any breakup feels permanent. But as anyone can tell you, it gets a little easier with each day, and in that recovery period you learn so much about **your own strength, resilience, and confidence**. Some good ways to cope include talking to a professional, keeping your social calendar full with friends and family, and throwing yourself into work and your hobbies.

 it is also a good time to make a list of what you want (and don't want!) in a partner going forward

- Tour the Marqués de Riscal winery in Elciego, Spain.

■ TAKE CONTROL OF YOUR CAREER ADVANCEMENT.

Consider whether you're in a good place to ask for a promotion at work, and outline what you need to do to get it. Or, look into what degrees or certifications you could obtain to advance in your line of work. The future is yours!

■ *Visit an Amish community.*

■ Make a friend who's at least ten years older than you.

They can impart their wisdom from surviving their twenties, show you how to better manage bills, and give you the kind of relationship advice that only comes from a few decades of dating.

- **Stop smoking, or toss out any thoughts of trying it.**

- ## Develop a go-to cheap and easy dinner recipe.

You come home from a long workday, exhausted but ravenous, and open the refrigerator. What are you cooking? My personal favorites include pasta with broccoli and lemon zest, and a quinoa vegetable bowl.

- Mattress surf.

with protective gear

- Listen to every Beatles record.

- Belt out your favorite song on karaoke night.

I'm partial to anything by Britney Spears, myself.

- BUY A TELESCOPE.

find all your favorite constellations in the night sky

- Visit a candy factory and see how your favorite chocolate gets made.

but you can also find vegetarian and vegan versions

■ Try poutine in Canada.

Traditional poutine consists of French fries topped with gravy and cheese curds.

■ Take sailing lessons.

■ Face your biggest phobia.

If you're terrified of heights, hike the Grand Canyon; if it's sharks you fear most, try wading out into the ocean while holding a friend's hand. I'm really scared of heights, but I am grateful for each time I've **suppressed my anxiety** to look over the edge of a waterfall or climb a mountain ledge.

■ Watch hundreds of colorful hot air balloons soar into the sky at the Albuquerque International Balloon Fiesta.

■ **Go a whole day (or week, or month!) without complaining.**
Ugh, this is so hard. *See? I just blew it.* But making an effort to curb your griping will motivate you instead to spend that time appreciating what you do have.

Start your own composting pile.

If you have a house, you can simply toss your organic food scraps in a pile in your backyard and water and stir it regularly until it's **ready to feed your garden.** You can also compost in your apartment using a small box or bucket to collect the scraps. If your city sponsors compost pickup, simply chuck the compost materials into a designated bin. Check your town's website to see if you are eligible.

Perfect the art of home-brewed coffee.

Cut off all your hair.

Think how great it'll be to save time on styling your tresses in the morning. Having short hair is truly freeing—and besides, it's just hair. It'll grow back.

- Relive those high school romances with a date at the movies.

- Create a funny secret language with a friend.

- **Play text roulette.**
 Send a nice text message to a phone number that's one digit off from yours.

- Do a good deed and don't tell anyone about it.

■ Go out for a *really* expensive meal.

One of those seven-course ones with steak tartare, truffle pasta, and chocolate mousse that feels like angels' feet are dancing on your tongue. Short on cash? Plan it as a treat for your thirtieth birthday dinner.

you have time to save!

■ Take in a country music show at the famous Grand Ole Opry in Nashville.

■ TAILGATE AT YOUR ALMA MATER.

Cut out friends who don't add any value to your life.

Old friends are gold, as the adage goes, but sometimes it's okay to let fading friendships fade. A good rule of thumb is that with a solid friendship, **you can pick up where you last left off** without awkwardness or tension. And you definitely want to nix any toxic relationships from your life—anyone who belittles you, pressures you, or just makes you feel less than stellar about your awesome self doesn't need to be taking up your time.

Taste champagne in the Champagne region of France.

Sparkling wine technically isn't champagne if it's not made from grapes grown here. It is, though, still delicious.

■ Take a loved one to see his or her favorite professional sports team.

■ Have a classic horror movie marathon.

"Heeeeeeeeere's Johnny!"

■ Save money by clipping or printing coupons.

Sure, it might be only 50 cents off that orange juice, but all of that penny-pinching adds up. You can even put the money you save over time in a **special funds jar** to see just how worthwhile a little thriftiness can be.

- Book a last-minute flight to a place you've always wanted to visit.

- **Reduce your carbon footprint.**

Switch to LED or other low-energy light bulbs, bike or walk instead of driving, and make food choices that support low emissions (e.g., cutting back on your meat intake).

- WATCH RACECARS WHIZ BY AT THE MONACO GRAND PRIX.

■ Learn how to play the guitar.

Starter guitars are cheap, and the secret to learning to play music is that most songs stick to a simple chord formation. Here are some songs you can play on guitar with only three chords: "What I Got" by Sublime, "You Can't Always Get What You Want" by the Rolling Stones, "Cool" by Gwen Stefani, and "Amazing Grace."

■ Stand below the giant billboards in Times Square and take it all in.

■ Write a love letter.

It can be to a significant other, a friend, or yourself.

- ## Read *Walden* by Henry David Thoreau.

 Thoreau lived by himself at Walden Pond in Massachusetts for more than two years, and his thoughts on **civil disobedience, God, and transcendentalism** have left an indelible imprint on American philosophy. Thoreau's philosophical views will encourage you to delve into your own, and the strength he drew from solitude might even inspire you to get out into nature.

 take a break from your phone →

- ## TAKE A PUBLIC SPEAKING LESSON.

- ## Rake the biggest pile of crunchy fall leaves and dive right into the middle of it.

■ Quit a terrible job.

Life's too short to keep spinning your wheels at a gig that's making you miserable or not challenging you enough. Just make sure you have a plan for your next move, whether it's having a new job lined up, a freelance schedule in place, or having saved enough money to take a short hiatus.

■ Jump into a pool with all your clothes on.

■ Hold a giant garage sale.

Finally follow through with your **spring cleaning goals** and help friends and family do the same.

- **HELP SOMEONE CHECK AN ITEM OFF *THEIR* BUCKET LIST.**

■ Host a Wes Anderson movie night.

Anderson's engaging, character-driven films are all made in his signature surrealist style, and if you want to understand half of the Halloween costumes you'll see at parties in your twenties, you'd do well to get acquainted with the full Anderson canon. Some good places to start: *Rushmore, Moonrise Kingdom,* and *The Royal Tenenbaums.*

- **Eat a fresh crepe smothered with warm Nutella in France.**

- *Memorize lines from a popular TV show or movie.*

Keeping up with well-known TV shows or classic movies can be a great way to **find similarities** with coworkers and those friends-of-friends you run into from time to time.

- Call in sick to work and go on an adventure.

- **Figure out if you want to have kids.**

This is probably the most personal decision you can make, and only you can make the call for yourself. Babysit, check out parenting books at the library, and talk to parents you know to get a true feeling for everything that goes into having a child. (It's a lot!)

- **Grow your own vegetables.**

 Start with lettuce—it grows really fast! Herbs such as basil, cilantro, and rosemary are also a **good intro to gardening.**

 just imagine all the fresh pesto

- **Learn a few words in the language(s) of your ancestors.**

- # Be your parents' biggest fan.

 Your parents were your personal cheerleaders through thick and thin. Now it's your turn to support them through their new endeavors or life changes.

■ TRY HAGGIS IN SCOTLAND.

Just don't ask what's in it until afterward.

■ Kiss someone during a fireworks display.

■ Read 1984 by George Orwell.

Even if you read this novel in high school, it's worth cracking open again. Orwell weaves the topics of technology, surveillance, and political control into a vision of a dystopian future that often seems frighteningly close to something we could witness in modern times.

- Take a boat cruise around lower Manhattan at sunset.

- **Actually talk to the clipboard people.**

You know, the ones standing on the sidewalk representing various causes and asking if you "have a second." It's a tough job, and it will make their day to chat with a friendly face. Plus, you might be newly inspired to support a cause you believe in!

- Ride in a limousine.

■ Catch a Red Sox game at Fenway Park in Boston.

Check out the Green Monster, the name given to the park's epically tall left-field wall that prevents many home runs.

■ HOST A BURGER TASTE-TEST BARBECUE.

veggie burgers are welcome!

■ Tour the Motown Museum in Detroit, Michigan.

Crowds flock to this museum, nicknamed Hitsville USA. This house turned museum was the first headquarters of Motown Records.

- Pay for the order of the person behind you in the drive-through.

- SNORKEL WITH GIANT MANTA RAYS.

- Tee up at the Pacific Dunes golf course in Bandon, Oregon.

 The lush fairways of this famous course are blended into the natural coastal landscape, with an up-close view of the ocean.

■ Become a regular somewhere.

You'll probably move at some point in your twenties, and moving to a new city is tough. I've learned that one tiny way to **feel more at home** is to make the same place a routine stop, whether it's a café, a drugstore, or a wine bar. It feels warm and fuzzy when the barista sees you coming and has your drink ready to go for you, or when you can vent to your favorite bartender about your difficult day. You'll eventually meet your fellow regulars, too, and maybe develop a new, exciting friend circle outside of work.

■ Buy lemonade from a kids' lemonade stand.

Mere cents for you, but the smiles on their faces will be a priceless reward.

■ Pay for a round of shots with your friends.

- **See the *Mona Lisa* in person.**

 It'll be smaller than you expect, but still breathtaking.

- **WIN MONEY FROM A SCRATCH-OFF LOTTO TICKET.**

- **Spend the weekend in a luxe treehouse.**

 Did you know you can rent one online?

crust too!

- Bake a pie from scratch.

- ## Take in the grandeur of the Taj Mahal.

 The white marble palace in Agra, India, is actually a mausoleum. It was commissioned by Emperor Shah Jahan in 1632 in honor of his late wife.

- ## Stay up all night with a roommate or close friend.

 Eat junk food and laugh until your sides explode— **metaphorically**, of course.

■ Help a child write a letter to Santa.

Bonus points if you make sure that "Santa" writes back.

■ Learn how to do the Heimlich maneuver.

You just might save a life.

■ Have a side hustle.

Sell your crafts on a website such as *Etsy* or *ArtFire*, coach Little League, drive for a ride-sharing company, or start your own business.

■ Get a really, really comfy pair of shoes.

The older you get, the more you'll appreciate function over fashion—and a shoe with a nice cloudlike sole over a trendier shoe that pinches your toes.

■ LISTEN TO *ROLLING STONE*'S "40 MOST GROUNDBREAKING ALBUMS OF ALL TIME."

■ Shop till you drop at the Mall of America in Minnesota.

- **Learn how to make a fire without matches or a lighter.**

- **Break open a piñata and eat *all* the candy.**

— if this doesn't make adulthood worth it, I don't know what does

- **Read *To Kill a Mockingbird* by Harper Lee.**

Atticus Finch will inspire you to choose what is important to you over what others might think, and the book's themes of race and injustice will spark reflection about how far— or not far—society has come.

- EAT CHEESE CURDS AND GAWK AT GIANT BUTTER SCULPTURES AT THE IOWA STATE FAIR.

- # Figure out your perfect nap length.

 Does a full hour make you groggy? Does fifteen minutes just leave you cranky and disoriented? Take regular dozes until you've calibrated the ideal nap situation for *you*, and then employ power-nap mode as needed. This comes in handy as you get older—trust me.

- Memorize a cool fact to surprise people.

■ Turn off your phone for twenty-four hours.

Eek! Don't worry, you've got this.

■ **Do a state park road trip.**

Grab your driving buddy and hit the pavement to see some of America's most spectacular sites, whether you're into red rocks or really tall trees. Depending on how much time you have, you can see two parks in one trip, such as Yellowstone and Arches, Yosemite and Big Sur, or Joshua Tree and the Grand Canyon.

■ GET A DEGREE.

■ Date someone who isn't your "type."

Do you usually go for skinny hipster types? Take a chance and go out with that cute jock. Get a beer with a blonde if you're usually only into brunettes. You might be surprised at who makes your heart flutter—maybe your soul mate doesn't have curly hair or play football, like you once thought.

■ Try purple cauliflower.

it tastes the same as the regular ol' white stuff, but it's more fun to eat

■ See a show on Broadway.

- **Drink coconut water from a fresh coconut.**

Bonus points if you crack it open yourself!

- **Let yourself feel uncertain.**

This is a crazy, constantly changing time in your life. It's okay to not have a clue sometimes!

- **Go to your high school reunion.**

Even though you already know from stalking these people on social media who has kids and who runs marathons, seeing all your **old crushes and frenemies** in person, ten years later, is way better. Reminiscing with your old buds will bring up great memories you totally forgot about.

remember the days when your biggest worry was what to wear to prom?

■ **TOUR AN AUTHENTIC WHISKEY DISTILLERY IN SCOTLAND.**

■ *Fly first class.*

■ **Forgive any grudges you have against your siblings.**

Some siblings are the best of friends, while others have rockier relationships. Even if it means accepting that you might never have the bond with your brother or sister that you really want, it's important to try to **let go of family resentments** that might be polluting your mental space and move forward in love and grace. You can initiate the process of forgiveness with small acts of kindness toward your sibling, or a direct apology for past misgivings. Wish your sibling a good day, check in about something you know she has had a difficult time with recently, or ask her to lunch.

■ AUDITION FOR A REALITY TV SHOW.

Will you actually end up on *The Bachelor*? You never know!

■ *Get a couple's massage.*

■ Make your own ice cream.

It's easier than it sounds, especially if you get an automatic ice cream maker. Plus, you can experiment with your own flavors, such as dill pickle lavender. ←

okay, maybe not that one

- Visit Matamata, New Zealand— now called Hobbiton—where the Lord of the Rings movies were filmed.

- **Know when to try harder.**

And when it's time to walk away.

- Tuck into a deep-dish pizza in Chicago.

Accept your "flaws" as part of what makes you *you*.

I didn't fully feel like an adult until I learned how to stop beating myself up for things I considered "wrong" about me and just embraced them as part of what makes me, me. I'm an introvert, and so I'll probably never be that extrovert rattling off amazing ideas around the conference table at work. But I *can* be that person who emails everyone after the meeting with ideas that were percolating in my head. I'll never have a "perfect" body, but I do have one that's strong and healthy. Sometimes I worry too much, and I drink way too much coffee. **And you know what?** Those are things I've grown to love about me, and I wouldn't change it for a second.

■ READ THE ENTIRE HARRY POTTER SERIES.

■ Ride in a helicopter.

- **Do yoga every day for a full month.**

 Even if it's just the Downward Dog pose before you go to bed.

- **Take a tour of a pineapple farm in Maui.**

- **Take a trip to Vermont during the fall.**

 Stroll around with a thermos of coffee or hot apple cider and check out the changing leaves.

■ Watch the documentary *Food, Inc.*

If you haven't seen it, this powerful look at the American food and agriculture industry will forever change the way you look at what's on your plate.

■ Start a social media group for all the YourFirstName YourLastNames out there.

■ Adopt a rescue pet.

Or foster a rescue pet! There are tons of organizations through which you can provide a **safe haven for dogs and cats** while they wait to find their forever home.

■ Go crowd surfing.

Carefully.

■ WALK ON A GLACIER.

■ Build your own website.

Owning yourname.com is pretty baller. Services such as *Squarespace* and *WordPress* walk you through the process step-by-step. Or, if you're a little more tech-savvy, you can learn how to code your own site.

- See the faces of George Washington, Abraham Lincoln, Thomas Jefferson, and Theodore Roosevelt sculpted in granite on Mount Rushmore.

- Watch the sun rise and set in one day.

The sunrise will be the hard part.

bring lots of coffee

- Discover your favorite artists at the Museum of Fine Arts in Boston.

■ Drive on historic Route 66.

One of America's first highways, Route 66 once connected Chicago to Santa Monica, California. It was a famed route for those who wanted to move to the West. It's since been replaced by other highways, but you can still drive on stretches of it in Illinois, Missouri, New Mexico, and Arizona.

■ START A JOURNAL AND WRITE DOWN FIVE THINGS YOU'RE GRATEFUL FOR EVERY NIGHT.

■ Eat authentic Japanese ramen.

A far cry from those ten-cent packets you made in your dorm room microwave, **real ramen** consists of hearty broth, veggies, a soft-boiled egg, and the best part: tasty handmade noodles.

■ *Take a selfie with a celebrity.*

■ Learn a new language in your spare time.

Got five minutes to spare while waiting in line at Walgreens? That's enough time to learn how to say "How much does this shampoo cost?" in Italian using an app such as Duolingo or Memrise.

■ GO TO A RELIGIOUS SERVICE THAT'S NOT WITHIN YOUR TRADITION.

■ Rent a convertible for the day.

Riding in a convertible is like **no other experience**. You just feel so amazingly...outside.

■ Go on a cookie crawl in your hometown.

It's not hard to get up early if you know what awaits you: a delicious cookie at every bakery you can find.

— and BYOGOM:
bring your own gallon of milk

■ Hold a koala bear in Australia.

■ Try a trending exercise method.

Hot yoga, CrossFit, barre...maybe you'll find a routine you want to continue, or maybe you'll walk away with new respect for the people who willingly do this every week.

■ Sit for high tea in London.

■ Embrace your love for fashion and beauty trends, or your total lack of interest in them.

Being interested in style doesn't make you shallow, and not being interested doesn't make you lazy. What matters is **how you feel** in the clothes you choose to wear. Do those patterns some people call "clashing" make you feel bold and ready for the challenges of a new day? Rock those florals and stripes. Do your favorite pink clogs make your feet feel like they are walking on a cloud? You do you!

and maybe join in!

- **Watch old men play dominoes on Calle Ocho in Miami.**

- **Go on a second date with someone even if the first date wasn't knock-your-Converse-off amazing.**

 First dates are nerve-racking. Often people feel awkward and clam up, or ramble in an attempt to fight off those uncomfortable silences. You shouldn't give someone who was disrespectful or just obviously not a match a second chance, but if you're on the fence about it and the first date was fun, go ahead and meet up again.

- **LEARN HOW TO PARALLEL PARK.**

 Take ballroom dance or salsa lessons.

Debut your skills at the next wedding you attend!

■ Ask your parents to teach you their favorite card game.

■ **Go on vacation without posting anything about it on social media.**

Or at least wait until you get back to post so you can enjoy every screen-less moment of your trip.

■ TRY ESCARGOT.

■ Read a banned book.

A personal favorite is *The Color Purple* by Alice Walker. Check out www.bannedbooksweek.org for more information and updated book lists.

■ Upgrade to the spa pedicure.

You're worth it.

■ **LEARN HOW TO JUMP-START A CAR.**

■ Go apple picking and make as many apple-centric recipes as you can.

Try apple crisp, applesauce, and apple bread. ←

the possibilities are almost endless

■ Sip mint juleps in a fabulous hat on the sidelines of the Kentucky Derby.

Know the difference between an IRA and a Roth IRA.

I won't spoil it for you.

Trust your intuition more.

I wish I'd listened to my gut more in my twenties. Some of my biggest regrets stem from times when I knew deep down that something or someone wasn't right, but soldiered ahead anyway. Growing older means developing confidence in your own abilities to know **who you are and what's best for you**, and that includes when to back away from a situation that just doesn't feel right.

Paint your bedroom a crazy color.

■ Try virtual reality.

Jet off to exotic worlds without ever leaving your couch.

■ WATCH A SPACE SHUTTLE TAKE OFF.

■ Stop comparing your life to someone else's for a full week.

Thanks to modern technology, it's easy to get caught up scrolling through other people's lives online. But this can become a trap when you compare what you see online to your own life. Try **taking a break** from things that perpetuate these comparisons, and if you can, stretch one week to two, or even a full month. Also keep in mind that people put their best face forward on social media; they don't post about their loneliness, relationship problems, or long days at work.

- Start a friendly food fight with friends or a family member.

- **Watch *Reality Bites*.**

 If you've ever struggled with feeling adrift in your twenties, you'll relate to this 1994 classic about four young Texans figuring out life and love in a sea of aimlessness.

- Take a cheesy tourist picture at the Leaning Tower of Pisa.

- String twinkly lights around your bedroom.

- **Read works by famous poets.**
 Some good places to start: the oeuvres of Langston Hughes, E.E. Cummings, and Annie Dillard. Visit PoetryFoundation.org to search for poets by name, period, or theme.

- Learn how to juggle.

 three or more balls!

■ Try an authentic New York City bagel.

The proper NYC bagel should be a) the size of your face, b) so fresh out of the oven you don't even need to toast it, and c) accompanied by a *very* thick cummerbund of cream cheese.

■ Go to Easter Island and see the moai statues in person.

Did you know they have full bodies beneath the ground?

■ GET A LIBRARY CARD.

■ Take artsy candid pics of a friend when she isn't looking.

This is the friend we secretly all want: the one who gives us great new profile picture options.

■ Turn all your brown, overripe bananas into a heavenly loaf of banana bread instead of throwing them away.

■ Blow bubbles.

There really aren't enough bubbles in adulthood.

a great alternative to a regular kiss when you have dry, chapped lips

■ **SHARE A BUTTERFLY KISS ON A COLD WINTER DAY.**

■ **Switch to seltzer instead of soda.**

It's hydrating, doesn't have any sugar, and comes in fun flavors.

■ **Pay for movers.**

I've never once paid for people to haul my heavy junk to a new apartment and thought afterward, "You know, that *wasn't* worth the money."

■ Read *Hyperbole and a Half* by Allie Brosh.

Based on Brosh's mega-popular web comic, *Hyperbole and a Half* tackles topics such as mental health, family, and the tumultuous nature of life, all in a simplistic style that will have you laughing throughout.

■ Take a romantic ride on a Ferris wheel.

■ Climb Machu Picchu.

■ **TRY OUT A POPULAR ADVENTURE TREND WITH FRIENDS.**

Escape rooms, murder mystery dinners, zombie laser tag—a fun and trendy outing is sure to **shake up** the usual hang-out routine.

■ **Hang around the arena exit at a concert to catch the band as they're leaving.**

This might be your only chance!

■ **Donate your old clothes and unwanted items instead of selling them.**

Sure, you might make $20 from a clothing resale store, but your donation will **go a long way** for someone in need.

■ JOIN A COED SPORTS LEAGUE.

■ **Watch a multipart Ken Burns documentary.**

Burns's detailed, intriguing accounts of events such as World War II won't put you to sleep like other historical films might. Check out *Baseball* if you're a sports buff, or screen *The Civil War* if you want a stunning look at American history.

■ *Pick a bouquet of wildflowers for someone you love.*

- **Travel to a region of the United States you've never visited.**

Grew up in Ohio? Check out Southern California. Never been to the Northeast? Time to hit NYC and Boston! America is huge, and you don't need a passport to explore new places.

- **Send your friend a care package full of goodies, just because.**

- **VISIT A NUDE BEACH.**

You may find yourself embracing a **new freedom** in your own skin.

■ Live in an imperfect apartment with (almost) perfect people.

Now is the time to live in that loft with three crazy roommates or go in on a beach house with your best friends. Some of your best memories later in life will be staying up late with your roommates, talking about anything and everything.

■ Eat the best dim sum of your life in Hong Kong.

■ READ *THE HANDMAID'S TALE* BY MARGARET ATWOOD.

Atwood's creative dystopian version of the United States will make you think about politics and human rights in new ways. Compare this brilliant novel to the television adaptation.

- **Drive on the Pacific Coast Highway.**

- **Ask people to hang out with you.**

 When I moved to New York at age twenty-six, I kept a digital list of my friends. If I was staring down an empty weekend, I would open my list and start texting people to see if they wanted to hang out. It was really scary to make the first move! Even now, I tend to assume everyone else is busy doing fun social things while I'm just sitting on my couch looking at my phone. But the older I get, the more I think we're all just sitting at home waiting for other people to take the initiative to ask us to do things. The worst that can happen is you get a no.

 you can be that person!

- **Get your own set of business cards.**

even if you find it corny today

■ Watch a TV show that was popular when your parents were your age.

The beloved television of a certain decade can shed light on what was valued during that time, and what your parents found humorous or touching.

■ **Make your own natural cleaning products.**

Hint: use baking soda and vinegar to clean *everything*.

■ **Bury a time capsule.**

■ Make a streaming music playlist for someone special.

You know, the modern version of a mixtape.

■ See the Liberty Bell on Independence Mall in Philadelphia.

■ *Write a poem.*

Haiku count!

■ SEE THE GREAT WALL OF CHINA.

■ Stop worrying about what other people think of you.

If I took one lesson from my twenties, this is it. I spent so much time preoccupied with what other people were thinking about me, when the truth is that those people were too busy focusing on their own lives to worry about me. No one was staring at me in the gym thinking about how ridiculous I looked. No one was sitting at his or her work computer thinking about what was on my screen. No one on the bus cared that I accidentally blasted three seconds of Katy Perry before I plugged in my headphones. It sounds crazy, but **one of the most soothing thoughts** in the world is that no one is really thinking about me that much at all.

■ Kiss someone under the mistletoe.

- Take a mental health day off from work and do whatever you please.

Everything will be fine without you.

hey, sometimes you just need a day

- Make popcorn in an old-fashioned popcorn maker.

Soak in one of Mexico's pink lakes.

In the village of Las Coloradas, tiny plankton and algae give lakes a vibrant pink hue. You can even spot flamingos striking a pose in the water.

Give your car a silly name.

It's just more fun to tell someone you and "Daisy" are running errands all day.

HOST A SEASON FINALE PARTY FOR YOUR FAVORITE TV SHOW.

Have a regular video chat date with someone you love who's far away.

■ Read *The Opposite of Loneliness* by Marina Keegan.

Marina Keegan was a talented writer who died in a car accident just five days after graduating from Yale University. This collection of her essays, published posthumously, is a poignant look at the **trials of young adult life** that will move you to tears.

■ Take a delightfully warped selfie in the *Cloud Gate* sculpture (aka the Bean) in Chicago.

■ Make your own hummus.

It's healthy, cheap, and ridiculously easy—just blend together chickpeas, tahini, olive oil, and whatever extras you want to add for flavor.

it tastes best with warm pita scooped directly out of the food processor

- **Learn how to use Photoshop.**

- **Cry in public without shame.**

 Sometimes the tears refuse to wait, and that's okay. Better to get them out! You'll most likely never see any of these people again, and some of them—probably many of them—know what it is like to be in your shoes.

- **Celebrate your favorite holiday in a different country.**

■ Watch *Milk*.

In this 2008 film Sean Penn stars as Harvey Milk, an influential activist for gay rights and the first openly gay person to be elected to public office.

■ Jump off a waterfall while holding hands with someone.

■ Find a self-care routine that works for you.

It could be doing a face mask every Sunday, going for a long run every Monday evening, or soaking your feet in a foot spa at least one night each week. Whatever you choose, make a point to set aside some time to **rest and recharge** as often as you can.

■ **Have a professional look over and edit your résumé.**

Even if it's just your dad.

■ *Snorkel along the Great Barrier Reef.*

■ DO AT LEAST ONE SMALL THING EVERY DAY THAT IS OUTSIDE YOUR COMFORT ZONE.

■ Throw a surprise party for someone.

And have one thrown in your honor. ←

you can always hint

■ **Have a passionate moment in the rain.**

Kiss, dance like crazy, scream out your frustration—we've all thought about that movie moment.

■ Watch the Olympics in person.

■ Meditate.

Meditating doesn't have to be a two-hour event with special beads and bowls. One of the best purchases I ever made was a $4 meditation app for my phone. There are many out there, so you can choose one that **suits your needs and price point**, plug in your headphones, and bliss out. I'm a big fan of listening to meditations on planes and at night right before bedtime. There are also a number of great books out there that contain quick and easy mediations, so you won't need to bend around a busy schedule or allot more than five minutes.

— unless you want to

■ Find a four-leaf clover in a lush green meadow.

■ STAY IN A HOTEL OR BED-AND-BREAKFAST IN YOUR OWN TOWN.

Get that vacation experience without having to travel far away.

- **Watch amazing movies and spot celebrities at the Sundance Film Festival.**

- **Splurge on a really nice massage.**

 With hot stones, candles, and everything.

- *Give gelato a try.*

 Gelato contains less air than traditional ice cream, which gives it that creamy, oh-so-rich texture.

- Pick a pumpkin from a pumpkin patch and carve that sucker into the scariest (or funniest) jack-o'-lantern.

- *Accept a compliment.*

For a large part of my twenties, I couldn't let a compliment pass without my insecurities piping up to deflect it. "Oh, it's *so* old," I would say when someone liked my necklace. "It wasn't really that good," I'd answer someone praising my PowerPoint presentation. "My colleague really deserves most of the credit," I'd hedge when my boss complimented a project that I'd put my fair share of work into. To turn my self-effacement around, **I started simply replying "thank you"** to each compliment: no qualifiers, no deflections. It's a small change, but it's truly helped me feel prouder of myself and my accomplishments.

- CATCH A FOUL BALL AT A BASEBALL GAME.

■ Donate your old books to the library.

Books can be *so* hard to part with, but just think of all the other people who will get to discover new favorite novels!

■ READ *BLACKOUT: REMEMBERING THE THINGS I DRANK TO FORGET* BY SARAH HEPOLA.

Sarah Hepola's memoir about her struggles with alcohol in her twenties and spending her thirties trying to get sober will resonate with anyone who's ever been tempted to drown their problems in a whiskey glass. Her **deft exploration** of her own childhood and the social factors that encourage young people to party hard will make you think about your own experiences with alcohol.

■ Make breakfast for your significant other on a Sunday morning while she sleeps in.

■ Take a food foraging tour.

Learn how to hunt for wild mushrooms, find edible flowers, and finally learn which berries you can eat off the bush.

■ Go to therapy.

I've seen a therapist on and off for most of my life, starting in high school for personal issues, and later in life for my chronic anxiety and some devastating breakups. My therapists have helped me explore the roots of my negative thoughts and **challenged all my assumptions**. Plus, it's the chance to talk about yourself for an hour—who wouldn't like that? Start with one session, then decide if it is something you want to continue.

■ Dance the tango in Montevideo, Uruguay.

- Go on a cycling trip through the Andalusia region of southern Spain.

- **Make your own mochi.**

 These tasty Japanese rice flour cakes are actually easy to make by hand. Fill yours with red bean paste for a burst of earthy sweetness.

- Finally start flossing your teeth every day. ←

 okay, at least every other day

■ Read *The Life-Changing Magic of Tidying Up* by Marie Kondo.

You've probably had friends who read Kondo's book on simplifying possessions and then suddenly started throwing things away and rolling all their socks into neat little spheres. Her signature KonMari organizational method involves getting rid of any item you own that doesn't "spark joy," which is not only a good thought exercise, but also a practical one for twenty-somethings **who move constantly** and are tired of schlepping boxes of college T-shirts and random souvenirs from apartment to apartment.

■ Learn how to laugh off awkward moments.

■ VISIT THE MARK TWAIN HOUSE AND MUSEUM IN HARTFORD, CONNECTICUT.

Highlights of Clemens's Victorian mansion include the lush conservatory and the billiards room, which doubled as the author's office.

■ Drive throughout the night with someone.

Play music or just enjoy the peaceful feeling of being the only two people awake.

■ Make your own pasta.

As in the actual noodles! It's easier than you think, and you don't need one of those crank-operated presses. You can roll out the dough with a rolling pin and use a knife to cut it into whatever pasta style you desire. The **taste difference** from store-bought pasta will really stun you.

■ People-watch at a restaurant or dive bar.

It's a real microcosm of humanity.

■ Go to Eeyore's Birthday Party in Austin, Texas.

Yes, that Eeyore from the Winnie the Pooh stories! Dress up in a donkey costume, put on your saddest face, and get ready to have a blast at this annual festival, which donates its proceeds to a variety of nonprofits.

■ Make a snow angel.

■ GO GEOCACHING.

It's the most entertaining hobby you've probably never heard of: people stash "caches" of stuff along with a logbook at specific locations and participants use GPS and mapping technology to find them. Geocaching is a **great way to explore your city** and find real-life buried treasure. Go to Geocaching.com to learn more and get started!

■ Ride a tandem bike.

■ **Upgrade your cheap furniture.**
You can find countless tutorials online that teach you cheap and easy ways to reupholster your secondhand couch or turn your inexpensive bookcases into the bright focal point of your living room.

■ Tour the storybook castles of Germany.

■ Know that money won't solve all your problems.

As tempting as it is to hope you win the lottery, wealth won't satisfy your deepest human need for love and connection. I know, I know: I often ruminate on how having my student loans paid off would change my life immensely. But **resist the urge** to put chasing money at the very top of your to-do list at the expense of other things that are more important, such as family, work-life balance, and quality time.

■ Make your own yogurt.

You can buy a fancy yogurt machine, but all you really need is a heating pad or other source of warmth to get your yogurt fermenting.

■ GET REALLY GOOD AT BILLIARDS.

- Swim with manatees in Florida.

- Host a board game party.

- Read *Their Eyes Were Watching God* by Zora Neale Hurston.

Hurston's classic 1937 novel probes themes of gender, race, and identity. Janie Crawford's quest to discover her true self will inspire you to seek your own independence from whatever may be holding you back.

■ Go to a drive-in movie theater.

■ Participate in NaNoWriMo.

No, it's not the newest tech craze: it stands for **National Novel Writing Month**, and it takes place in November. Your goal is to complete a novel in just thirty days. It's intimidating! Luckily, there are online communities and resources to cheer you on as everyone works toward the same goal.

■ Find a mentor.

Whether it's someone in your career field, or someone you just admire, seek out an individual through your company or social events who can offer guidance.

■ **LEARN HOW TO MAKE A MEAN GRILLED CHEESE SANDWICH.**

■ *Dye your hair a wild color.*

Silver? Blue? Mermaid green? One bright streak of neon pink?
The rainbow's the limit!

■ Babysit for family or friends so they can shower, see a movie, or just go shopping by their damn selves.

for free

■ **Go to Coney Island to see the famous Nathan's Hot Dog Eating Contest.**

The current record stands at seventy-two hot dogs eaten in ten minutes. *Seventy-two!*

■ Be the best man or maid of honor in a wedding.

■ **Eat an authentic Cuban sandwich.**

Roasted pork *and* ham, pickles, and mustard, all smashed together and toasted to perfection.

if only to meet hot strangers

■ Take a solo vacation.

■ **Buy your favorite frozen treat from a passing ice cream truck.**

Because you're never too old to shout, "Ice cream truck!" and run outside when you hear that familiar jingle floating around the corner.

■ TALK TO A CAREER COUNSELOR.

■ Read *Infinite Jest* by David Foster Wallace.

Wallace's walloping, 1,079-page masterpiece tackles topics like drug addiction, competition, family relationships, and compassion with **vibrant realism**. It's no easy tome, but you'll emerge with a deeper grasp on the importance of empathy.

■ Try caviar.

■ Come up with a new family tradition.

Maybe you can open presents on Christmas Eve instead of Christmas Day, or start meeting for a big breakfast on the last Sunday of every month.

- **Learn how to create a homemade gift.**

 Make candles, wreathes, or cookie-baking kits to give friends and family members gifts that are personal—and affordable.

- See the *Spoonbridge and Cherry* sculpture at the Walker Art Center in Minneapolis.

- Ogle cute pups at the Westminster Dog Show.

- Read the poem "The Second Coming" by William Butler Yeats.

 Yeats's spooky modernist poem will give you a deeper understanding of postwar Europe. You'll recognize several **popularized phrases** like "things fall apart" and "slouching towards Bethlehem."

- **Bake your own bread.**

 Absolutely indisputable fact: bread is delicious. So is the amazing smell wafting out of the oven as it bakes.

- Get a subscription to a print newspaper and read the news (on real paper!) each morning.

Go to the top of the Empire State Building.

Don't worry, it's only **eighty-six flights of stairs**! Okay, there's also an elevator.

Shuck an oyster.

READ A HOLY BOOK FROM COVER TO COVER.

especially one from a tradition you weren't raised in

or take a hike on a local trail

- Backpack through the Rockies.

- See *The Little Mermaid* statue in Denmark.

- Complete "The 36 Questions That Lead to Love," from *The New York Times*.

This series of questions from a psychological study promotes increasing vulnerability as you go. The questions are said to foster romantic intimacy between any two people who talk them through (even if they've never met before). Find the questions online.

■ **Host a fund-raiser for a cause you believe in.**

This can be anything, from something small, like a bake sale, to something big, like a gala.

■ **LEARN HOW TO SAY "I LOVE YOU" IN TEN DIFFERENT LANGUAGES.**

■ **Read "If You Forget Me" by Pablo Neruda.**

This **beautiful poem** will remind you of the people you once loved, and the ones you hope to never lose. Try not to cry!

■ Throw a midnight breakfast party for your friends.

Tell everyone to wear PJs, and whip up some waffles, bacon, and mimosas.

■ Stop putting pressure on yourself to be an early success.

Did you know that Julia Child worked in advertising before writing her first cookbook at age fifty? Or that Jon Hamm was thirty-six when he was finally cast in his breakout role on *Mad Men*? The world of fame may seem like it's populated with people who are barely pushing twenty-three, but **resist the pressure** to have it all figured out and to be on top of your game in your twenties: the best may be yet to come.

■ Hug your parents every chance you get.

it's actually a permanent art exhibit

- Visit the iconic fake Prada store in Marfa, Texas.

- **Turn your family's favorite recipes into a recipe book.**

Design a cool cover, and then give them out as inexpensive, sentimental holiday gifts.

- **TAKE ON A LEADERSHIP ROLE AT WORK.**

Volunteering to lead a project or instruct others is an important step in your **career development**.

- **BELLY UP TO A WARM BOWL OF NEW ENGLAND CLAM CHOWDER ON CAPE COD.**

- *Test-drive a luxury car.*

- Read *The Perks of Being a Wallflower* by Stephen Chbosky.

 One of the greatest coming-of-age novels, *The Perks of Being a Wallflower* follows quiet, introverted Charlie through high school as he explores the world of drugs, sex, love, and friendship.

■ **Go on an Alaskan cruise.**

Change up the typical Caribbean
cruise trip.

■ **Eat a fresh lobster roll in Portland,
Maine.**

■ Start a project that scares you.

not as in a photo gallery of
evil clowns, but one you've
always wanted to try but
haven't for fear of failure

■ Nab a seat in the audience of your favorite talk show.

■ **Learn how to edit simple videos and make fun compilations for your friends.**
It's one of the best free— and thoughtful—gifts!

■ Get really good at solving crossword puzzles.
The New York Times daily crossword is the gold standard, but tabloid magazines have some fun ones too.

■ Have a beer at the Pelican Brewing Company's pub in Pacific City, Oregon.

This pub sits right on the beach in front of the majestic Haystack Rock, where you can see a stunning view of the Pacific Coast while enjoying a brew.

■ See the Hollywood sign.

Even if it's just from an airplane passing by.

■ LEARN HOW TO MAKE ORIGAMI CRANES.

■ Read "Howl" by Allen Ginsberg.

This sprawling poem, first read by Ginsberg in 1957, ushered in the work of the Beat Generation, a countercultural group of writers and thinkers. Ginsberg's championing of the artistic class and nonconformists resonated with his generation at the time, and the themes of religion and philosophy are timeless.

■ Ride a cable car in San Francisco.

■ Make your own cinnamon rolls from scratch.

They taste so much better. ←

and you're in total control of how much icing you put on top

- Read the full poetic works of Maya Angelou.

Splurge when it matters.

From razors to umbrellas, the differences in the more expensive, well-made items you usually skip over for no-name, value versions will astound you.

Watch baby sea turtles hatch.

You can spot tiny turtles waddling their way back to the ocean on beaches in Sri Lanka or Costa Rica, or in the US on the coast of Florida. If you're up for the **cutest volunteer gig ever**, you can even join a SEE Turtles conservation trip.

pay off your student loans faster!
save for a down payment!
pay down your credit card debt!
move out!

■ Figure out a budget that works for you.

No sane human being enjoys budgeting. I personally would rather eat a bowl of glass shards than sit down and take a good hard look at my debit card purchases. But alas, keeping a tighter rein on your money has **tons of benefits**. Pick some of your key financial goals and do some research on how to make them happen. An easy way is to get a phone app that links to your bank account and does all the calculating and analyzing for you. It's definitely depressing to get that alert that you've spent $75 on cheese fries this month, but maybe it *is* time to start making your own cheese fries at home.

■ READ EVERY NOVEL BY STEPHEN KING.

■ Feel that butterflies-in-your-stomach sensation with someone.

It's so fun to have a crush, even if you know it won't go anywhere.

■ **Get a fitness tracker to see how many steps you're taking each day.**

■ **Learn how to negotiate your salary.**

Young people in particular are much too hesitant to ask for more money during the job offer process. I've felt the reluctance myself, believing that I should just be grateful someone wants to give me a job, take what the company offers, and shuffle off happily. But one thing you learn with time is that the beginning is the **best time to push for a higher salary**, because it's much harder to work your way up incrementally once you're already established at a company. And now as a manager who hires people, I truly respect employees who know their value and negotiate for more money. Resist the urge to settle for less than you deserve.

■ *Win a giant stuffed animal at a carnival game.*

■ Swim with pigs in the Bahamas.

On Nassau and the Exumas you can splash around in the water with adorable pigs and snap some awesome selfies.

■ Learn how to mountain bike.

■ FALL IN UNREQUITED LOVE.

Okay, hear me out. Loving someone who loves you back is perhaps the best feeling in the world. But I've learned more in my life from those doomed crushes, the ones where the guy's opinion of me ranged from short-lived curiosity to total indifference. Through learning to handle rejection, I've nurtured **a lot of confidence and faith in who I am**, and I've learned a lot about my own behavior. It has also helped me navigate rejection (in all forms) with more grace.

■ *Ride a carousel.*

■ **Join in on a Color Run.**

Grab your friends for this 5K race that sends you sprinting through clouds of brightly colored cornstarch thrown by volunteers at each kilometer mark. You'll emerge sweaty, triumphant, and covered in shades of the rainbow.

■ **Write an article for your former high school or college newspaper.**

You'll strengthen your résumé, learn about the editing process, and get to see your byline (priceless!).

- Have a breadstick-eating contest at Olive Garden.

- **Sleep in a hostel in a foreign city.**

 It's cheap—like, shockingly cheap—and an amazing way to meet new friends.

- *Be an extra in a movie.*

■ Figure out your go-to bar drink.

It can be a cosmo, a scotch neat, an IPA, or just a club soda with lime, but it feels good to know what you want as you slide into the seat. (I personally go with Jameson and soda—gritty enough at a dive bar, but respectable enough at a bar that's more posh.)

■ SEE THE CHANGING OF THE GUARD AT BUCKINGHAM PALACE.

■ Write an assertive email.

Ask for what you want. Don't waver.

■ TRY UNI.

It's the edible part of a sea urchin; it's super creamy.

■ Buy a bunch of cheap lottery tickets and host a scratch-off party.

■ Watch *Last Train Home*.

This 2009 documentary follows a Chinese couple who leave the city of Guangzhou to travel home to their rural village—where their infant children still reside—for the lunar new year. Each year over 130 million Chinese people make the same trip back to their rural homes for the holidays, forming the world's **largest migration** and temporarily turning China's big cities into abandoned ghost towns.

■ Ride an airboat through the bayous of Louisiana.

■ Finish a challenging jigsaw puzzle.

You can commemorate this feat by shellacking and framing it.

■ Send a message in a bottle.

■ Float in a sensory deprivation tank.

You take off all your clothes, hop into a pod filled with extra-salty water, and float in **total silence and darkness**. I'll admit that when I tried this I was terrified of getting bored or feeling claustrophobic (both physically and in my thoughts), but the time went by quickly and I felt really Zen afterward.

■ Make your own peanut butter.

■ Walk the Siq in Petra, Jordan.

The Siq is the stunning ten-foot-wide entrance to the ancient city of Petra. You'll emerge from the gorge to the sight of Petra's gorgeous treasury.

- **Throw a cupcake decorating party.**

Include those little edible silver balls. Everyone loves those.

- **GO ON A TOUR OF THE WHITE HOUSE.**

- Sign up to be a Big Brother or Big Sister.

■ Attend the Gilroy Garlic Festival in California.

Stuff your face with garlic fries, sample garlic ice cream, and even meet Miss Gilroy Garlic herself. (Yes, there is a garlic-themed beauty pageant.)

■ Create a hilarious holiday card.

■ DRAW AN ARTISTIC MASTERPIECE ON THE SIDEWALK WITH CHALK.

or as close as you can manage

■ *Pray.*

■ **Ride a horse full-tilt through an open field.**

Just not in Julia Roberts's style—in a wedding dress as you flee the ceremony.

■ Read *One Hundred Years of Solitude* by Gabriel García Márquez.

Márquez's tale of seven generations of the Colombian Buendía family is a complex exploration of human nature.

- Learn how to throw darts.

- **Go to a restaurant by yourself.**

 And read instead of looking at your phone! A book is just as good company as your phone, and it's way more relaxing. Work up the courage to tell the hostess "Just one, please!"

- RIDE A GONDOLA IN VENICE, ITALY.

■ MAKE YOUR OWN KOMBUCHA TEA.

Kombucha is full of **healthy probiotics**, and it gives you something pleasantly tart to sip on instead of soda.

■ Beat a video game or phone game.

■ Go to a Minnesota meat raffle.

At this very Midwestern event, you play for the chance to win cuts of different kinds of meat. Proceeds usually go to charity, so rest assured that you're *bacon* money for a good cause. (*Groan.*)

- **GIVE ONE STRANGER A COMPLIMENT EVERY DAY.**

- *Go sandboarding in Dubai.*

- **Read *Ulysses* by James Joyce.**

Set in Dublin, Joyce's poignant novel reveals themes such as family and remorse through complex twists and turns.

- Tour a cheese factory and stuff your face with free Cheddar samples.

- **Go to a DIY pottery store with friends for an impromptu art party.**

 Have a round of drinks first. You know, to boost your creativity.

- Eat authentic pizza in Naples, Italy.

■ Tell your parents you appreciate everything they've done for you.

No parents are perfect, but all parents love you in the best way they can. Let them know that you're thankful.

■ Camp under the stars.

■ Read "Do Not Go Gentle Into That Good Night" by Dylan Thomas.

Used for decades to inspire the living and mourn the dead, Thomas's **epic poem** is a classic that will rouse optimism for the future and inspire you to live every moment to the fullest.

- **Go skinny dipping.**

- **RIDE THE TRANS-SIBERIAN RAILWAY.**

- **Recreate the Abbey Road photo.**

The iconic crosswalk is only a five-minute walk from the St. John's Wood station in London. Traffic might have to pause a bit for you to get your picture. ←

don't worry: the locals understand

■ **Learn how to play euchre.**

A cooler version of Hearts, this **social card game** is full of
tricks that will keep you and your friends on your toes.

■ **GO TUBING DOWN A RIVER WITH YOUR
FRIENDS AND A COOLER OF DRINKS.**

■ **Kiss the Blarney Stone in
Ireland.**

Legend has it that once you do, you're
bestowed the gift of eloquence.

- **FLOAT AND DAYDREAM AWAY IN THE EXTREMELY BUOYANT DEAD SEA.**

- ## Go to the Burning Man festival.

 This weeklong festival celebrates love, art, and magic at a temporary city erected in the middle of the Black Rock Desert in Nevada. Though it's famous for attracting people with "psychedelic" hobbies, one can attend the festival without partaking in these and have just as mystical a time.

- Plant a tree somewhere you can watch it grow for years.

■ **Read *The Art of Fielding* by Chad Harbach.**

Even if you're not a fan of baseball, Harbach's novel about a young shortstop will resonate with you for its exploration of romantic relationships and the quest for greatness.

■ Brew your own beer.

■ WATCH A JOUSTING MATCH WHILE EATING A GIANT TURKEY DRUMSTICK AT MEDIEVAL TIMES.

You can watch sword-fighting, jousting, and even falconry at this **dinner theater** that recreates the days of knights and lords. There are eight locations in the US and one in Canada.

Live on your own.

If you can afford it, there's **no sweeter pleasure** than coming home to your own space. The only dirty dishes in the kitchen are your own, and no one's ever hogging the bathroom when you *really* need to pee.

■ Read an author's entire canon.

Some writers have a **truly unique style** that can best be appreciated by reading, cover to cover, every work they've produced. Some great authors to start with: Anne Lamott, Haruki Murakami, and Toni Morrison.

you can find different literary canon lists online

■ Bake your best friend's favorite dessert.

And eat it all yourself! Just kidding. Give it to her, along with a nice note.

- **Watch a sumo wrestling match in Japan.**

- **Go dairy-free for a month.**

 You can go back to your cheese and butter if you really miss it, but you might end up liking the benefits to your body and overall health.

- Listen to Gustav Mahler's symphonies.

■ Buy your own Christmas tree.

Even if it's one of the smaller tabletop ones—it'll make your place smell great and light up your face with happy memories every time you come home.

■ Volunteer with Meals on Wheels.

■ Host a Star Wars party and screen the entire original trilogy.

Serve **themed snacks** like Jabba the Hummus and Flan Solo, and give guests **special prizes** for showing up in costume.

■ **Present a speech or idea in front of a crowd.**

■ *Sit (or stand) in the front row at a concert.*

■ **Get a tattoo.**

Or at least a semipermanent one through a company like inkbox or Ephemeral. You can get custom ones, so you can see if you truly like having Hello Kitty dressed as the Statue of Liberty on your wrist before you take the real plunge.

■ Know that it's okay if you have to move back home.

Hey, life happens! Whether you return home after a stint on your own or decide not to move out in the first place, it can be easy to eye your friend's cool new apartment and stew over your digs at *Chez Mom and Dad*. But while they shell out for full-price rent, you're **getting ahead** on your student loan payments or **putting money in the bank** for a down payment. Remember, it's only temporary!

■ Learn how to make a classic cocktail–or two.

Impress guests with your bartending skills.

■ HAVE A CHEESESTEAK IN PHILADELPHIA.

- Host a clothing swap party.

- **Buy noise-canceling headphones.**

 They will turn your public transportation commutes or flights into bouts of precious peace and serenity.

- Munch on fries seasoned with Old Bay from a boardwalk in Maryland.

■ Read *The Great Gatsby* by F. Scott Fitzgerald.

Seeing the Leonardo DiCaprio movie is dandy, but reading Fitzgerald's original tale of love and social class, set in the opulence of the 1920s, is a much richer experience.

■ Bring in breakfast for your whole office.

■ FLOAT ON THE BLUE LAGOON IN ICELAND.

There's nothing like getting off a long and cramped flight and heading straight to this **surreal hot spring**, where the water is bright blue and warmed by geothermal seawater. Wade up to the lagoon-side bar and grab a juice or wine, and let the water soothe your skin and soul. If you feel like splurging, you can sign up for an in-water massage.

- **Try ghost pepper hot sauce.**

 Buckle up your taste buds: ghost peppers are some of the hottest peppers in the world, and their chili sauce is no joke. Be sure to have some milk nearby to quench the heat a bit.

- Really *listen* to classical music.

- VOLUNTEER AT A SOUP KITCHEN.

- Sip a Shirley Temple at a swanky rooftop bar.

■ See a show at the Sydney Opera House.

It's so easy to get swept up in the majesty of the Sydney Opera House's iconic architecture that you might forget it's an actual performing arts center, hosting forty shows a week. From Shakespeare plays to rock concerts to kids' shows, there's something for everyone's taste.

■ Write a screenplay.

even if you never show anyone

- Shop at a floating market in Vietnam.

- Read *White Teeth* by Zadie Smith.

Smith's 2000 novel paints a poignant picture of friendship and family, while also getting down in the trenches of postcolonial Britain to explore tougher themes such as mental illness.

- LEARN HOW TO SABER A CHAMPAGNE BOTTLE.

■ Start a mug collection.

People sometimes tease me about buying a mug every time I travel, especially because I like to buy the tackiest, most garish one possible. But **every morning** when I make coffee, I pick one of my mugs and am reminded of the fun, crazy, or hilariously flawed trip I took.

■ Volunteer at an animal shelter.

■ Celebrate your half birthday.

Marking the occasion of the day six months before or after your birthday is a great excuse to go out to a nice restaurant, pop some bubbly, or just have a (second) fun day totally dedicated to you. Treat yourself!

■ Learn how to core a pineapple.

■ LISTEN TO THE HOTTEST SONGS FROM
THE YEARS YOU WERE IN MIDDLE SCHOOL.

Music is such a formative part of your
teenage identity, so the top hits from
your middle school days are definitely
going to take you back. Remember
your awkward dances at homecoming?
Blasting this one in your mom's
minivan? Grab your friends and relive
the fun (and cringe-y) moments.

■ Get your tarot cards read.

■ Stroll down Bourbon Street in New Orleans.

Drink a Hurricane and listen to jazz, or head there in March during Mardi Gras to throw on some beads and a costume and watch the parades.

■ Visit the Hot Springs in Arkansas.

■ TRY OCTOPUS.

It's not too fishy tasting, so even if you shun other seafood, give this a whirl.

- Ride a crazy roller coaster and buy the photo of you and your friends screaming your faces off.

- Learn a magic trick.

- PAY OFF A CHILD'S STUDENT LUNCH DEBT.

All across the country, students who can't afford their school lunches have to work off their debt or wear wristbands until their family can pay up. A donation both lets hungry students eat, and prevents kids from facing punishment for not being able to afford their lunch. You can get started by contacting your local school district to learn more about making a contribution.

- Stumble upon the set of a movie being filmed.

- Spend an entire day playing a marathon game of Monopoly.

- ## Visit the totally creepy Door to Hell in Turkmenistan.

The Darvaza gas crater has been burning continuously since 1971, when engineers set it on fire to try to prevent the spread of the poisonous gases.

■ Watch *Mean Girls*.

You'll instantly fall in love with this seriously "fetch" high school comedy about trying to fit in, which features some of the most frequently quoted lines in cinema history.

■ Buy school supplies for a local school.

■ Listen to episodes of *This American Life*.

Ira Glass has been hosting this award-winning radio show since 1995; it is now available via a free weekly podcast. There are over 600 episodes. If you want a good place to start, you can also listen to the show's spin-off podcast titled *Serial*.

■ Relax in a hot tub while it's snowing.

■ Read *The Kite Runner* by Khaled Hosseini.

Afghan-American Hosseini sets his touching father-son story against the backdrop of the Taliban regime, providing a window into an important part of world history.

■ THROW YOUR PET A BIRTHDAY PARTY.

- See the cherry blossoms bloom at the National Cherry Blossom Festival in Washington, DC.

- Read *The Goldfinch* by Donna Tartt.

 Tartt won the Pulitzer Prize for Fiction (2014) for this tragic yet inspiring novel that follows the story of a young boy whose mother dies in a terrorist bombing at an art museum.

- March in a Pride parade.

■ **Write a thank-you letter to your favorite high school teacher.**

You'll make his or her day, week, or even year, I promise.

■ Try your hand at deep sea fishing off the coast of North Carolina.

you might reel in a sailfish!

■ GET A BLANKET AND HEAD TO A ROOF-TOP NEAR YOU TO WATCH FOR SHOOTING STARS.

I'd share mine, but it's not printable

- Memorize one go-to joke that you can tell at parties.

- Write a real, snail-mail letter to your grandparents.

- **Watch the Macy's Thanksgiving Day Parade up close in New York.**

 Or go the night before and watch the parade balloons being inflated. (It's almost more fun!)

- Go to a lavender farm for some straight-from-Mother-Nature aromatherapy.

- **Leave a $5 bill for someone to find.**

Tape it to a vending machine or stash it behind soup cans at the grocery store. Day. Made.

- Be on TV.

■ Resist the urge to sign up for a new credit card, and rethink the cards you have.

The temptation to buy a bunch of new stuff you probably don't need isn't worth the free T-shirt. Some cards these days do come with tantalizing promises of travel bonuses and sweet perks, but only sign up for one if you know you can pay off the balance in full each month. If you can't, you risk getting swept away in a tidal wave of accumulating interest—and you'll end up paying way more than you originally spent. Take the time to reevaluate the credit cards you already have too. Are they still a good investment, or just adding stress to your financial load?

■ GET YOUR PALM READ.

■ Make your own pickles.

Pickles are delicious, and all you need are some mason jars, pickling spice, and whatever veggies your tastes desire. (I'm a big fan of pickling red onions to put on tacos.)

■ Drink Chianti in Italy.

■ Call or write your senator to support an issue that's important to you.

■ **Watch** *Fight Club.*

David Fincher's 1999 thriller stars Brad Pitt and Ed Norton, who play... well, I won't spoil it for you. But this classic film will challenge your notions of reality and what you want out of it.

■ **Read *Wild* by Cheryl Strayed.**

Strayed's beautiful memoir of her 1,100-mile hike on the Pacific Crest Trail follows not only her physical journey along the trail, but her emotional one as well.

■ Revisit a store that you used to frequent in your teens and marvel at how it's changed.

■ **TOUR THE JACK DANIEL'S DISTILLERY IN LYNCHBURG, TENNESSEE.**

Make sure you sample the wares. You know, for research.

- Enjoy a car-free afternoon strolling through a local street fair.

- **Spend a birthday entirely by yourself.**

Who knows what you like more than you do? Take the day to do everything you want to do without the pressure of entertaining others, whether it's a trip to the aquarium, a long hike, or just a movie marathon with ice cream in bed.

- *Eat "out" at a food truck.*

☐ Do the Polar Plunge.

What's a more invigorating New Year's Day tradition than stripping down to a bathing suit (or...less than that) in the dead of winter and jumping into freezing cold water?

☐ Teach someone how to read.

☐ See the Sahara Desert.

Did you know that the Sahara, the largest hot desert in the world, is comparable in size to the United States? You could fit the entire continental United States inside the Sahara with miles to spare!

- **Memorize one of your favorite poems.**

 You can recite it at a special event such as a friend's birthday, or keep it to yourself as a special memento.

- **BE THE FIRST PERSON TO APOLOGIZE AFTER AN ARGUMENT.**

- **Wear a pun-themed Halloween costume.**

 My personal favorite: get some cheering pom-poms, write the words "Go Ceiling" on a T-shirt, and presto: you're a **ceiling fan**.

■ Design a scavenger hunt around your town and send a group of friends on the quest.

■ Eat a Cronut.

You can find versions of this delicious croissant/doughnut hybrid around the world, but the real creation was invented by Chef Dominique Ansel in his Manhattan bakery.

■ READ THE BOOK BEFORE SEEING THE MOVIE.

13.1 miles

☐ RUN A HALF MARATHON.

Yes, it sounds daunting if you're a terrible runner like I am, but you can train for a half marathon **in only twelve weeks**. It's always okay to walk parts of it if you have to! If you are feeling brave, go for a full marathon, or a triathlon.

☐ Go to a destination wedding.

☐ Keep a plant alive.

If you know that you were born without green thumbs (I'm with you), try a cactus or an air plant. You can also check out low-maintenance potted plants such as the pothos or the snake plant. And if those *do* fail, there's always fake greenery.

☐ Go puddle-jumping in the rain.

☐ Immerse yourself in early 1900s New York with the words of Edith Wharton and Henry James.

Two American novelists who became pen pals and eventually real-life friends, Wharton and James spun tales of a New York society that was at once majestic and angry. City-dwellers (and visitors) will relate to their portrayals of a world balanced between enchantment and chaos.

☐ Volunteer at a nursing home or senior center.

- **Ride a bike through Amsterdam.**

 Scope out the tulips and sample the local coffee shops, if you desire.

- **TRAIN YOUR DOG TO BE A THERAPY DOG.**

- **Change up your coffee routine by trying something new.**

 If you're a cappuccino fan, you might dig a latte. Want something stronger? Deliver that precious caffeine straight into your system with two shots of espresso. There's also *zero* shame in delighting in coffee that tastes magically fall-like, so stay in your lane, pumpkin spice haters.

■ *Attend a black-tie gala.*

■ **Give a gift someone will remember forever.**

Write down ten (or more!) things you love about your loved one on colorful pieces of paper, put them in a mason jar, and garnish with a ribbon.

■ TAKE A KID TO HER FAVORITE THEME PARK.

- **Shake hands with a sitting president.**

- **Listen to the album *Blue* by Joni Mitchell.**

Mitchell's 1971 classic explores themes of love, relationships, and pain with a poignancy that's just as beautiful today.

- **Follow the news, but know when to take a break from it.**

In this day and age of the twenty-four-hour news cycle, there's always something to be totally terrified of: weather disasters, crime, political corruption. It's invaluable to be informed about what's happening in the world, but it's also a **thoughtful act of self-care** to realize when you need to turn off the TV or social media.

go for a walk and appreciate a moment of peace

■ Volunteer with Best Buddies.

This nonprofit organization pairs volunteers with people with disabilities to foster mentoring and friendships.

■ Visit the Sagrada Família basilica in Barcelona.

■ Try acupuncture.

adults can have fun staying cool too!

■ **Host a Slip 'N Slide party in the summer.**

■ **GO ON A SAFARI.**

■ **Learn how to network.**

Annoying as it may be, opportunity *is* often about who you know. Even if you're introverted like I am, motivate yourself to be more gregarious at work events, or even to just send an email to someone whose career you really admire.

■ Get lost in a corn maze.
(Then find your way out!)

■ SET UP AN EMERGENCY FUND.

An ideal amount to keep in savings is **three months' salary**.
But don't fret if you haven't made it all the way there yet;
anything is better than nothing. Personally, I save by having
a percentage of my direct deposit income automatically
transferred from my checking account into my savings account.
It's harder to miss that money each month when you never
even see it.

■ Listen to your parents'
favorite records of all time.

Drink around the world at Epcot in Disney World.

This fun ritual involves having a drink at each of the eleven countries that make up Epcot's World Showcase. Pace yourself, stay hydrated, and don't feel bad if you need to give up.

Read one new book a week for an entire year.

VISIT ALL FIVE GREAT LAKES.

Can you name them all? Here's a handy acronym: HOMES (Huron, Ontario, Michigan, Erie, Superior).

■ HOLD A TARANTULA.

■ Ask someone on a date.

Your armpits will be damp. Your heart will be pounding. You'll stumble over your words (even if you're texting). But what if he says yes?

■ Reread a book you had to read in high school English class.

■ Eat durian.

Called the worst-smelling fruit in the world, durian is native to Southeast Asia and looks like a cantaloupe covered in spikes. If you can get past its pungent aroma, durian tastes like almond custard. **Yum!**

■ Shower in a waterfall.

■ Watch *Donnie Darko*.

This critically acclaimed film follows Donnie, a teenager who's troubled by apocalyptic visions. (Or *are* they visions?) You'll walk away still thinking about the themes of teen angst and social convention, as well as the famous plot twist...

- Donate your hair to a cancer patient or charity.

- VISIT THE MAJESTIC HAGIA SOPHIA IN ISTANBUL.

- Practice being more vulnerable every day.

Sharing your life and heart with someone is scary, but the rewards are deeper relationships, a healthier sense of self, and the feeling of being truly understood by those around you.

- **Reach out to a favorite celebrity on social media.**

Maybe she will reply!

- Trek through picturesque Patagonia.

- Play Ultimate Frisbee.

■ Wade through a cranberry bog.

You've seen the guys in the Ocean Spray commercial do it, but did you know you can get your waders on too? Head to the coastal areas of Massachusetts in autumn for a cranberry bog tour that includes a wade through the marshes. You might even get to taste a tart handful of cranberries.

■ LEARN HOW TO DIY AN OIL CHANGE.

■ Take a ceramics or pottery class.

it's unbelievably soothing

■ *Eat a delicious shave ice in Hawaii.*

■ **Apply for your dream job.**
Even if it's a crazy long shot.

■ Watch a friend or family member's favorite TV show with her.

■ GO TO A NASCAR RALLY.

■ Write a letter to someone on a typewriter.

■ Learn how to knit.

In 2007, I bought some clumsy oversized knitting needles and cheap acrylic yarn and taught myself how to knit as a way to relieve the constant stress of being in graduate school. After a long day of studying and writing papers, I would come home to my tiny apartment in Connecticut, plop down on the couch with my needles, and not think about anything besides moving my hands. The end product? A lopsided, scratchy scarf that was much too short. But the outcome didn't much matter for me; **it was all about the soothing relief** of powering down my brain for an hour and focusing on nothing but rote stitch after rote stitch. If you do get really good at knitting, you can make homemade gifts for everyone on your holiday list, but it's also okay to savor a relaxing hobby that's just for you.

or speak at!

■ Attend the annual SXSW festival in Austin, Texas.

The brightest minds in songwriting, tech, and business flock to Austin every March for a summit of innovative ideas and amazing live music.

■ Tip your restaurant server $100 (or as much as you can afford).

■

Why do we assume we're going to change clothes thirty-two times a day while on vacation? Skip the heavy suitcase and pack a few strategic **mix-and-match items** instead.

■ Peep the American Gothic House in Eldon, Iowa.

Yep, it's the house that is **in the background** of the famous Grant Wood painting.

■ SPEND A FULL WEEKEND BINGE-WATCHING AN AWESOME TV SHOW.

■ Go to a full-moon party in Thailand.

An all-night beach party where you wear neon body paint and dance with travelers from around the world? Yes, please!

■ SEE STEEL DRUMS PLAYED LIVE IN JAMAICA.

■ **Tour the stunning Pink City in India.**

The city of Jaipur was painted pink in 1876 to welcome the Prince of Wales, thus earning its nickname the Pink City, and it has remained rosy ever since.

■ Get hypnotized.

■ Attend a Holi festival in India.

A Hindu celebration of love, this springtime festival starts with a religious ceremony and then later turns into a fantastic party where everyone throws colored powders at each other, creating some gorgeously vivid moments and memories.

■ HAVE A FAVORITE AUTHOR SIGN YOUR COPY OF HER BOOK.

■ Visit Las Vegas.

You've heard the stories, but now it's time you found out for yourself.

- Put a few quarters into someone's expired parking meter.

- Surprise someone with a weekend getaway.

- Watch all three Godfather movies.

This famous Mafia trilogy contains some of the most popular quotes in movie history ("Leave the gun, take the cannoli"), and its talented cast includes Al Pacino and Marlon Brando.

■ See the Four Corners monument.

The only place in the US where four states meet: Arizona, Colorado, Wyoming, and Utah.

■ Sample port wines in the Douro Valley region of Portugal.

■ Sign up to be an organ donor.

Did you know that at any given time there are over 100,000 people on America's national transplant waiting list? To register to become an organ donor, you can sign up online or in person at the DMV in your state.

- *See majestic mountain gorillas up close in Rwanda.*

Take classes on a handicraft.

Skills like woodworking, sewing, carpentry, and metalwork will come in handy when your pants pocket has a gaping hole, or the railing beside the stairs is coming loose. You may even find a new passion or regular hobby.

VISIT AN ORPHANAGE IN AN IMPOVERISHED AREA.

■ Figure out what your favorite kind of barbecue is.

Memphis, St. Louis, the Carolinas, Texas...it's a hard job, but someone has to smother it in barbecue sauce.

■ Collect a coin from every country you visit.

■ Read The Lord of the Rings by J.R.R. Tolkien.

Why? Are you seriously asking why?

- Ride Millennium Force at the Cedar Point amusement park in Sandusky, Ohio.

- Scope out *T. rex* footprints at the Dinosaur National Monument in Utah.

- Discover a great podcast and see it recorded live.

They're a perfect way to pass time in the car or subway, and you can find podcasts about anything, from your favorite TV show to world politics. Many podcasts also have open studios or statewide tours where listeners can watch a show being recorded.

Soak strangers in red wine at the San Vino Wine Fight in La Rioja, Spain.

This wild Spanish tradition kicks off every June at seven a.m. with a procession and a mass, followed by an epic wine war as participants use jugs, buckets, and even squirt guns to douse each other in red wine. (Don't worry, there's an **after-party** where you'll have the opportunity to drink wine too.)

DONATE BLOOD.

Go flyboarding.

In this incredibly fun sport, you strap into a surfboard-type device and hover above the water, propelled by jets under the board.

■ *Host a potluck dinner party.*

■ **Watch *Citizen Kane*.**

Orson Welles's first feature film, made in 1941, is widely considered the greatest film ever made. Not only is the cinematography amazing, but Welles's study of a character based on media mogul William Randolph Hearst is entertaining and engaging.

■ Hold a Ping-Pong tournament.

Do an electric run.

Held at night and illuminated with black lights, electric runs offer a spooky, exhilarating twist on the boring ol' 5K.

Feed a giraffe.

LEARN WHAT MUSIC, SURROUNDINGS, AND SETTINGS BEST HELP YOU FOCUS.

Maybe you need Beethoven and a cozy blanket, or bright lights and white noise.

Celebrate Día de los Muertos in Mexico.

The Day of the Dead is a multiday holiday celebrated throughout Mexico. It begins on Halloween and features festivals that include bright flowers, breads, sugar skulls, and decorations in honor of loved ones who have passed away.

Appreciate everything you learned and did in your twenties and enjoy turning thirty!

MY 5 BUCKET-LIST ITEMS

☐ --

DATE COMPLETED: --

☐ --

DATE COMPLETED: --

☐ --

DATE COMPLETED: --

☐ --

DATE COMPLETED: --

☐ --

DATE COMPLETED: --

ABOUT THE AUTHOR

A native of Ohio and Florida, Jessica Misener is a senior editor whose writing has appeared on *BuzzFeed, HuffPost, Cosmopolitan, The Atlantic,* and more. She's also worked as a T-shirt folder, dry cleaning assistant, grocery store cashier, librarian, and ancient Greek tutor, and holds a master's degree from Yale Divinity School. She lives in San Francisco, where she regularly eats twice her weight in burritos. The bucket-list items she most wants to check off are starting her own business, dyeing her hair pink, and petting a sheep in New Zealand.